EXISTENTIAL DOGS

HarperCollins*Publishers*

HarperCollins*Publishers*
1 London Bridge Street
London SE1 9GF

www.harpercollins.co.uk

HarperCollins*Publishers*
1st Floor, Watermarque Building,
Ringsend Road
Dublin 4, Ireland

First published by
HarperCollins*Publishers* 2021

10 9 8 7 6 5 4 3 2 1

ISBN 978-0-00-849403-2

Printed and bound in Latvia

MIX
Paper from
responsible sources
FSC™ C007454

This book is produced from
independently certified FSC™ paper to
ensure responsible forest management.

For more information visit: www.
harpercollins.co.uk/green

This book is dedicated to Sooty. He was a truly wonderful dog.

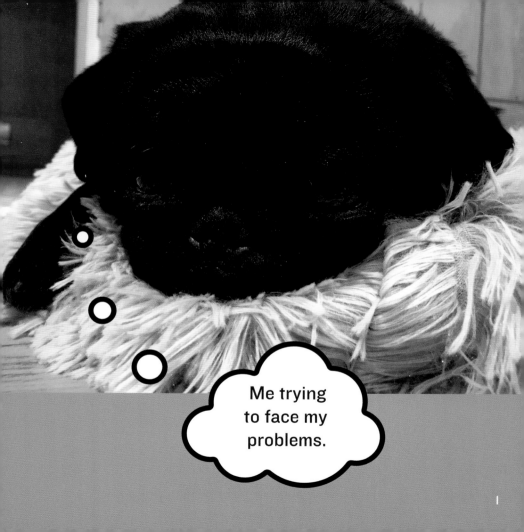

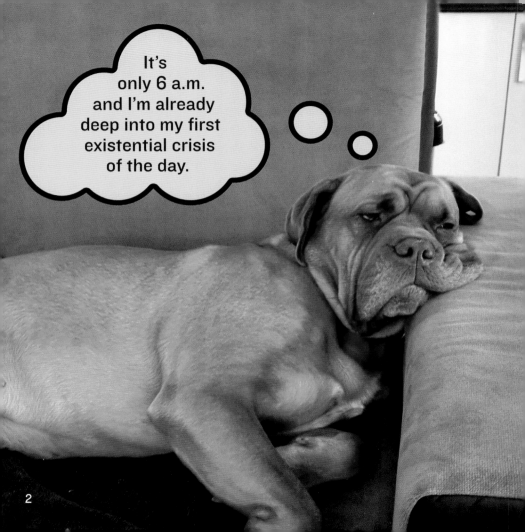

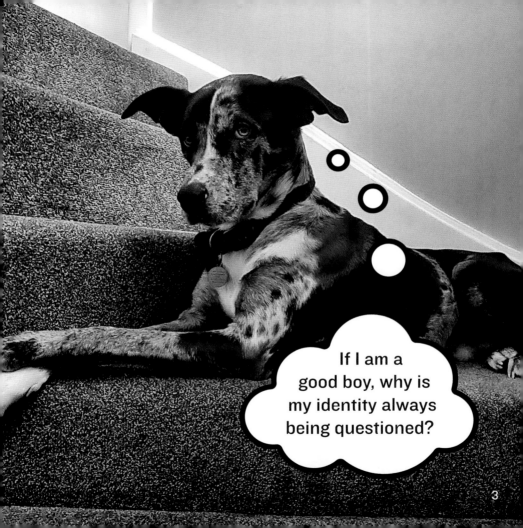

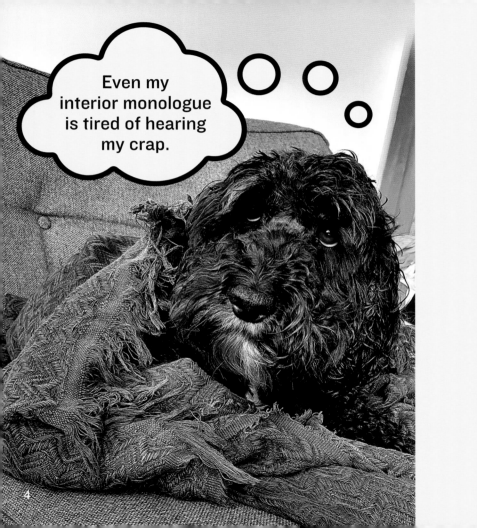

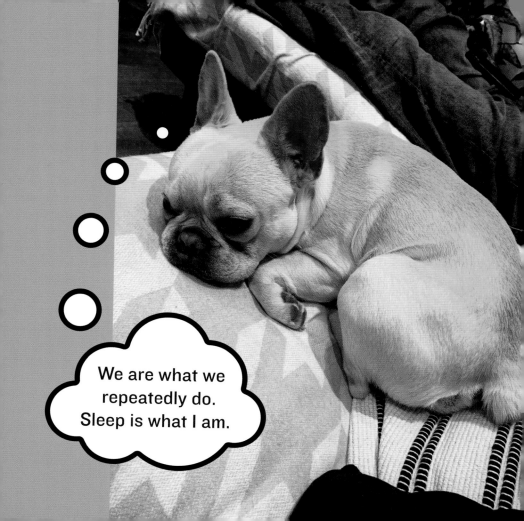

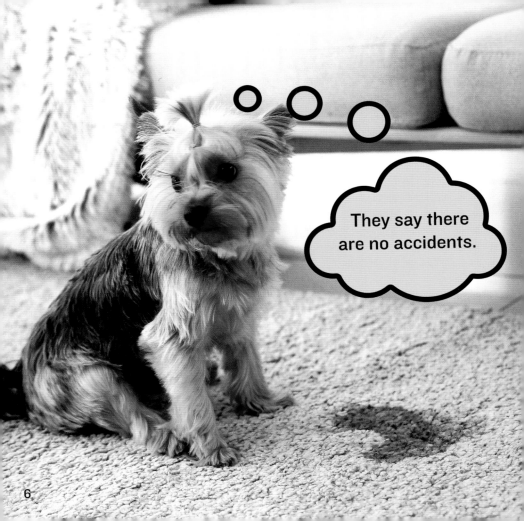

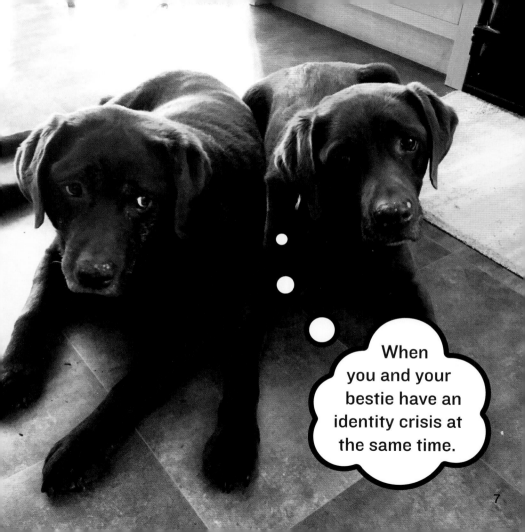

7

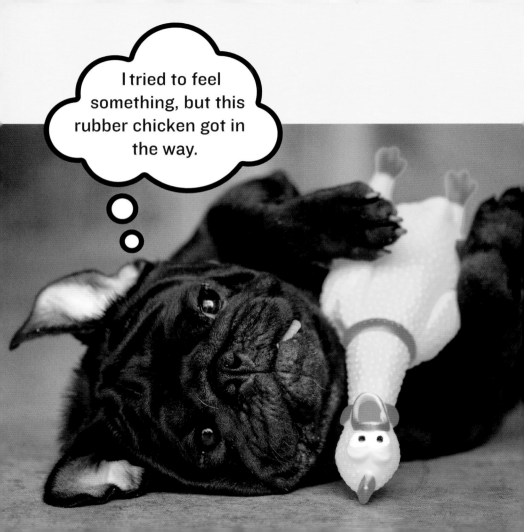

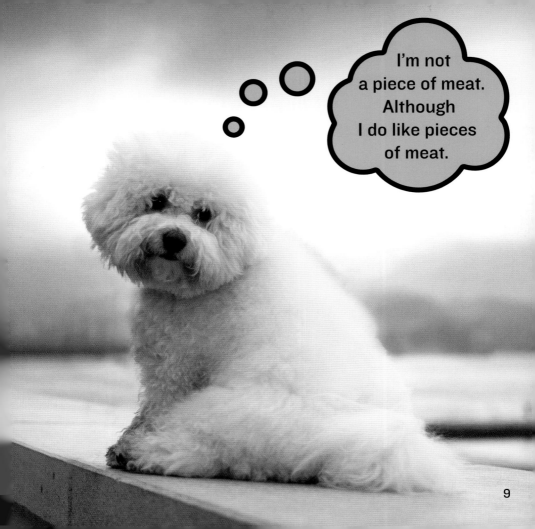

9

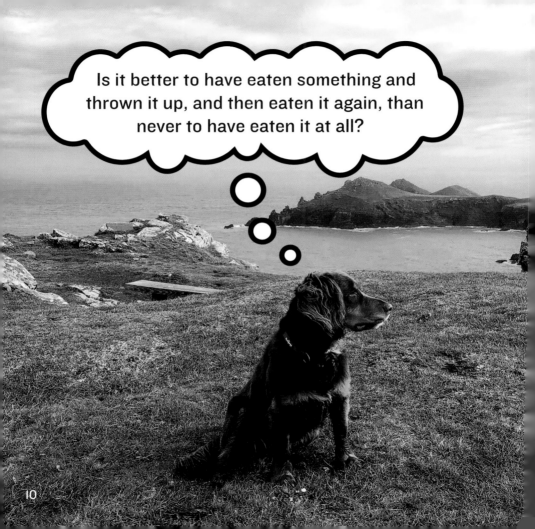

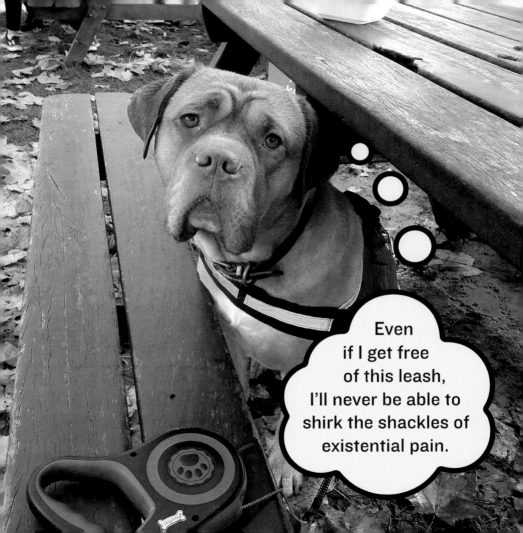

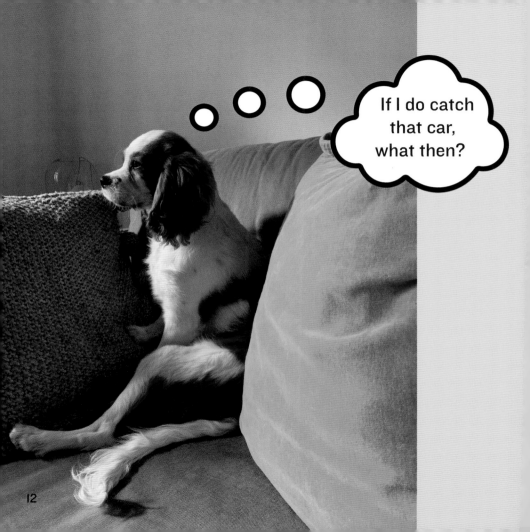

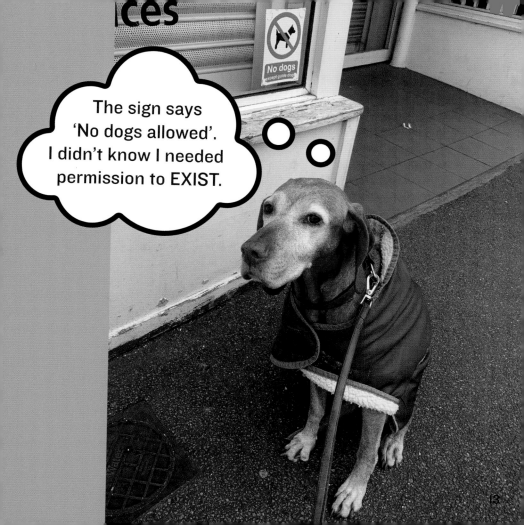

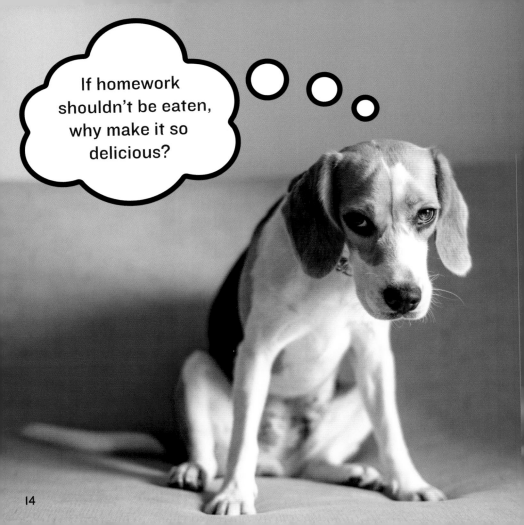

14

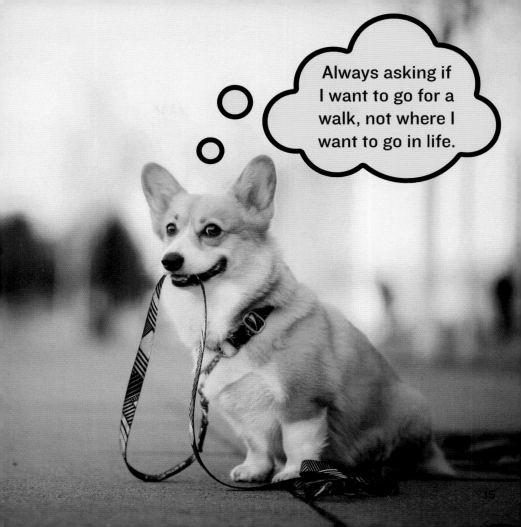

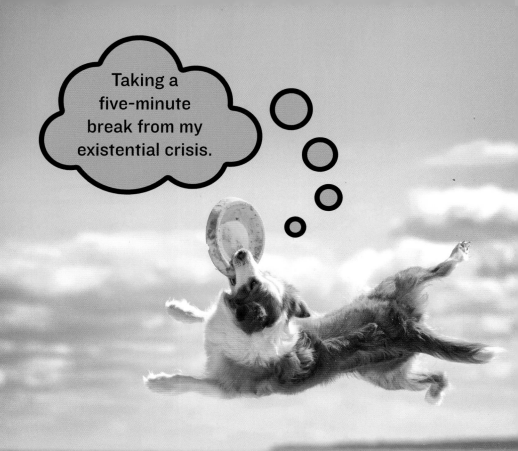

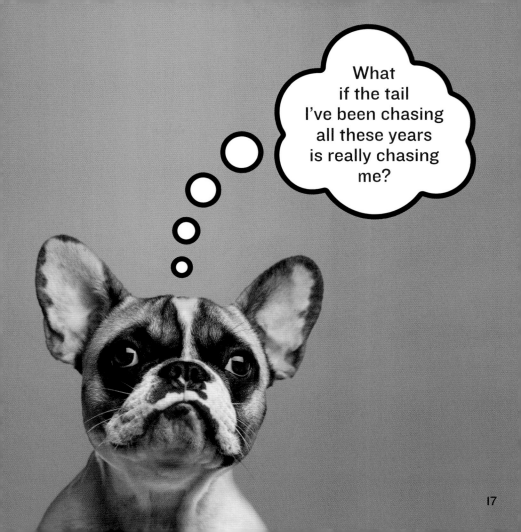

17

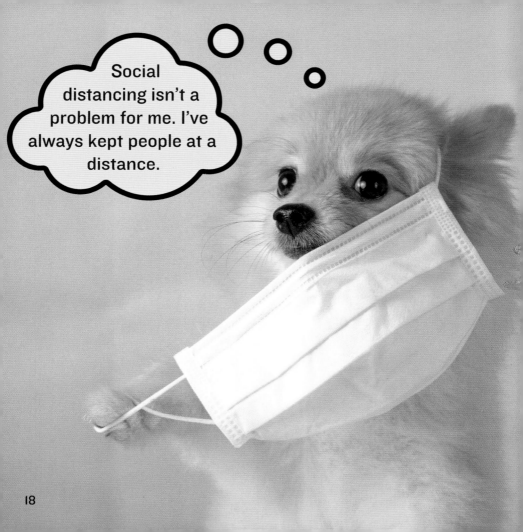

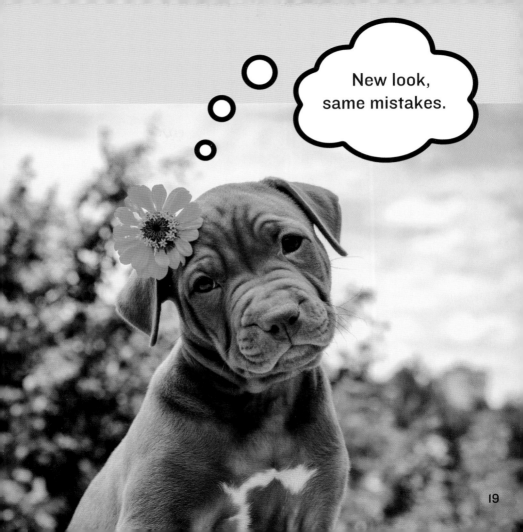

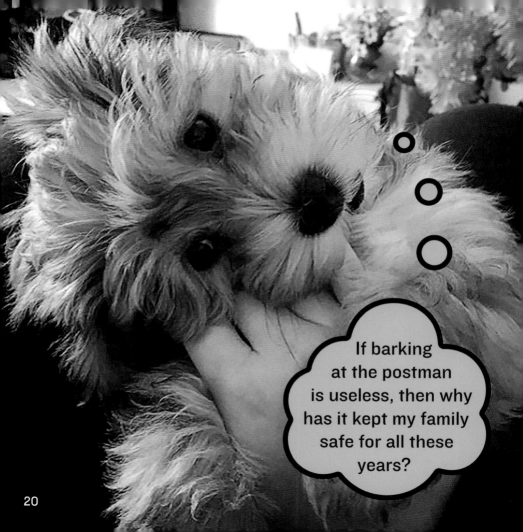

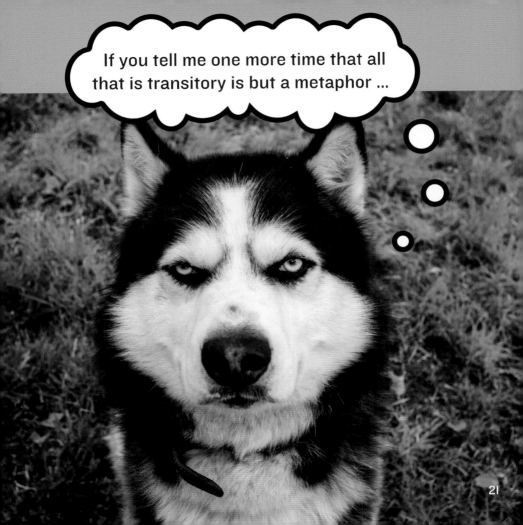

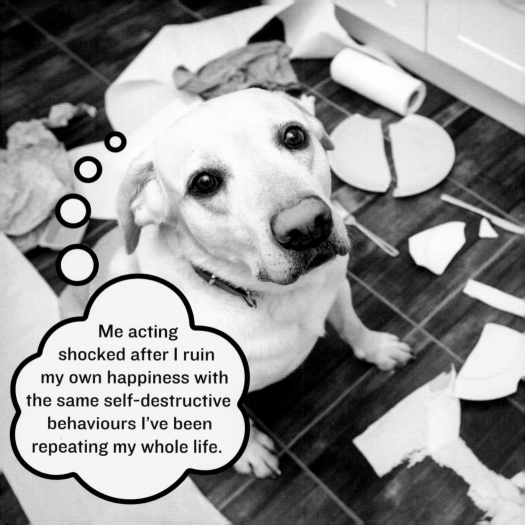

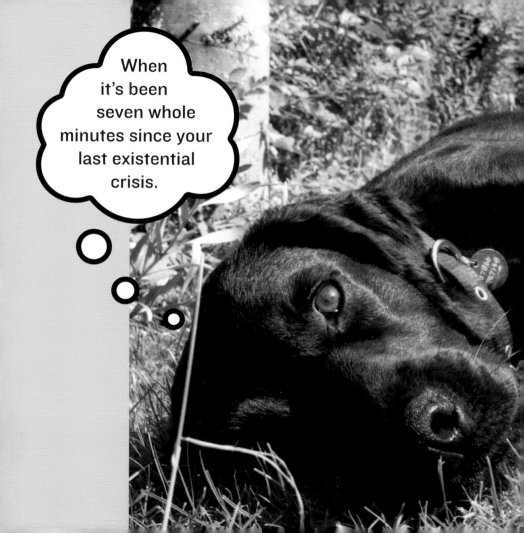

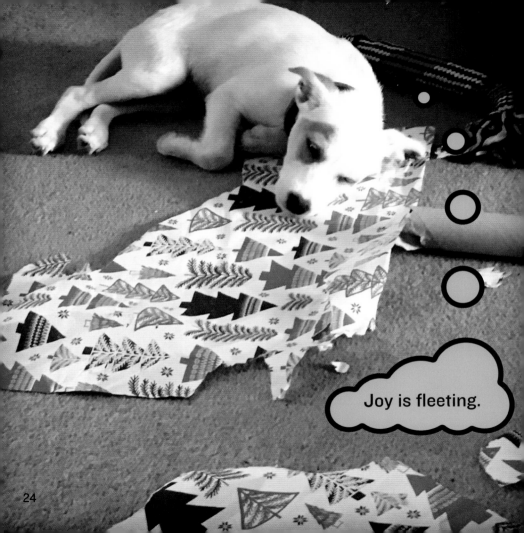

Joy is fleeting.

24

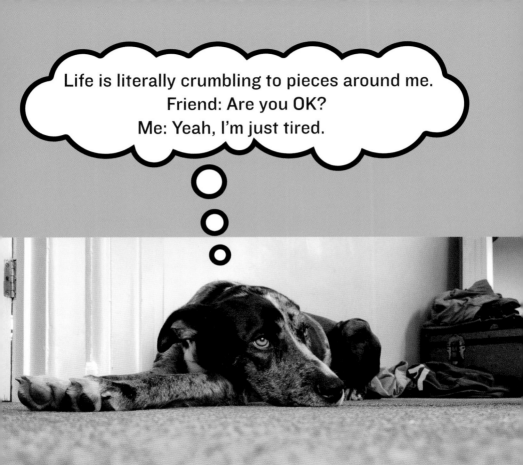

25

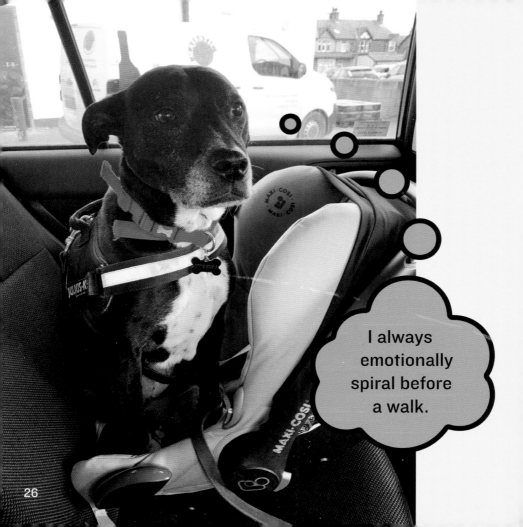

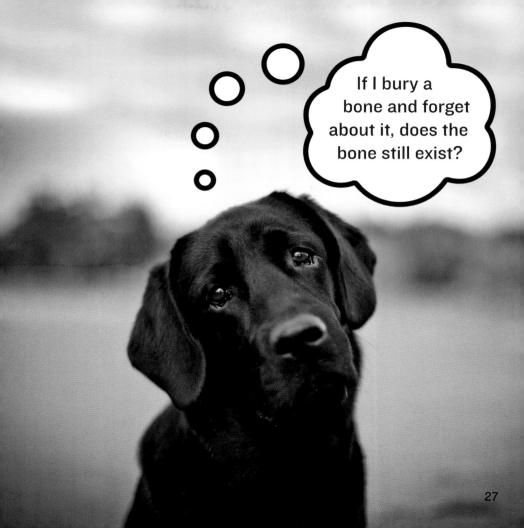

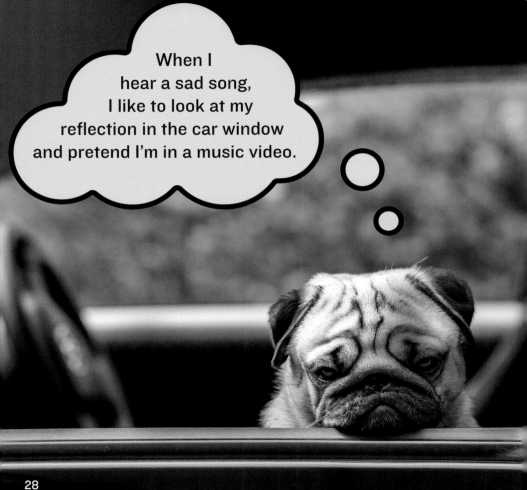

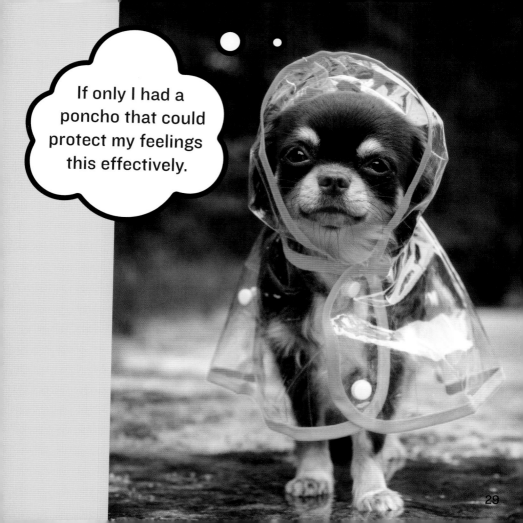

29

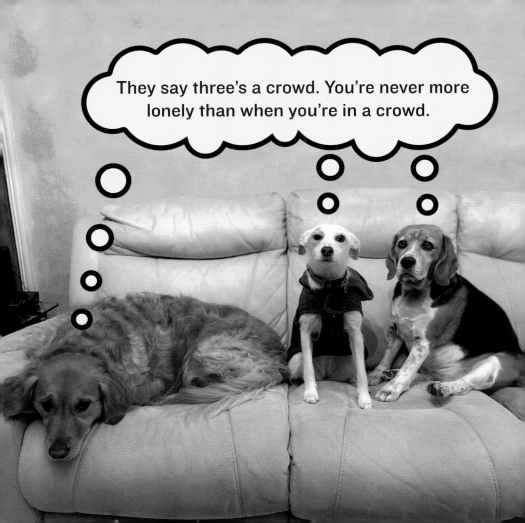

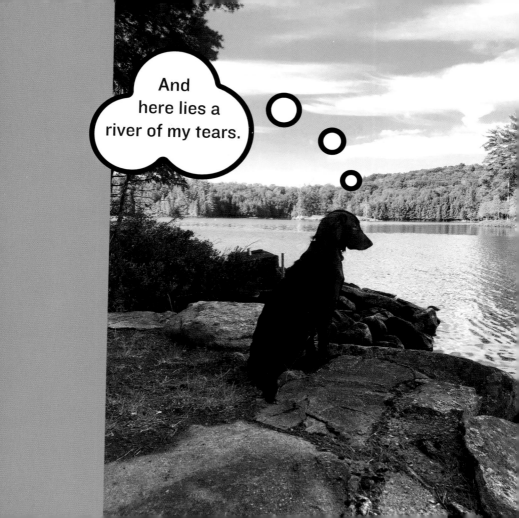

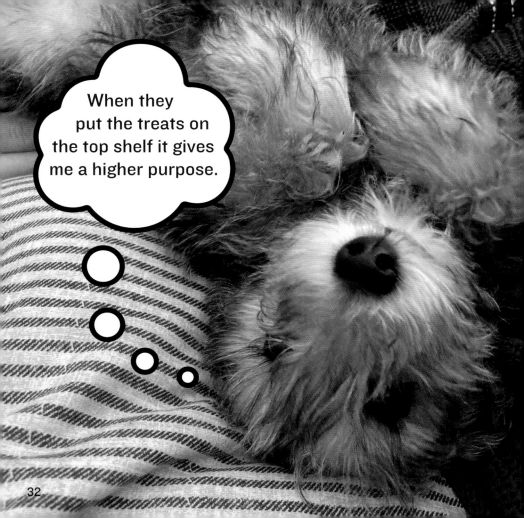

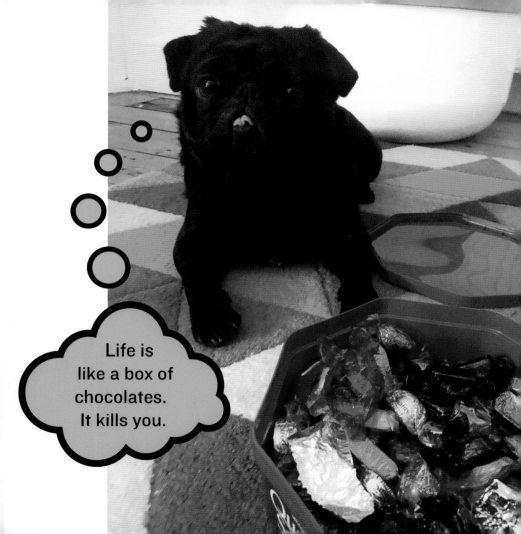

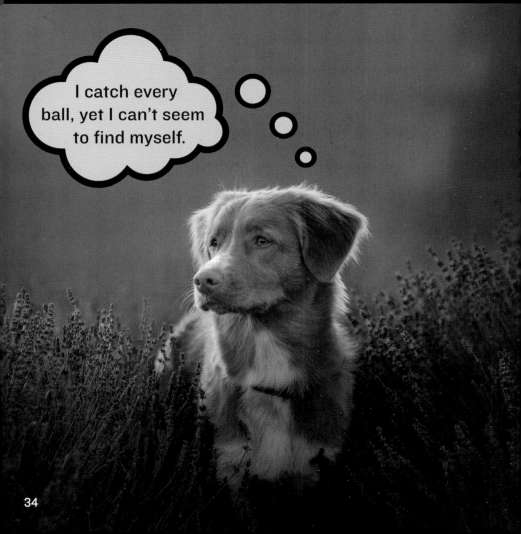

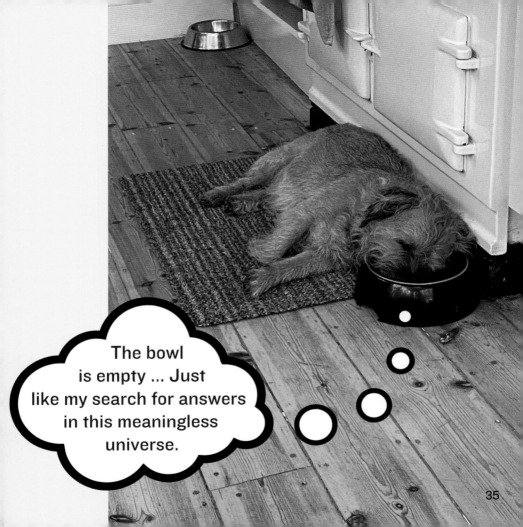

35

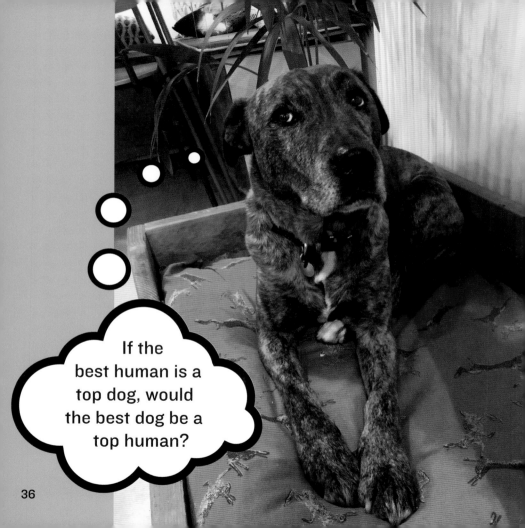

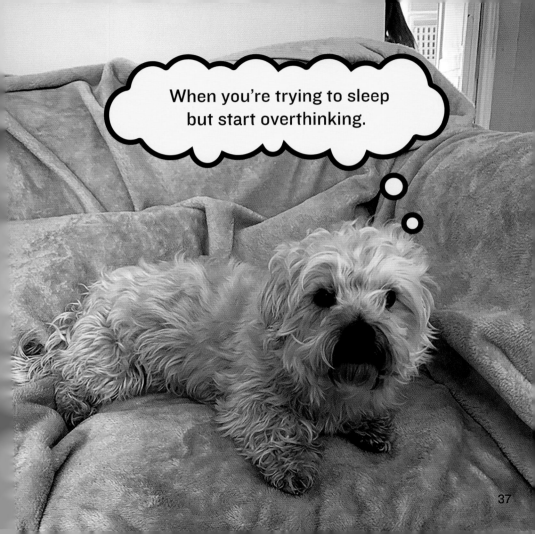

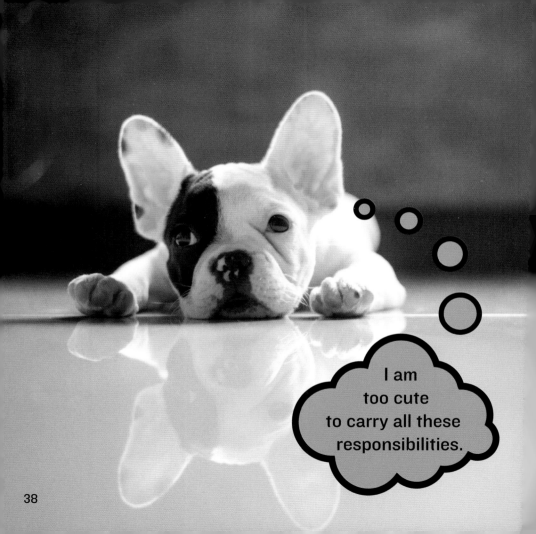

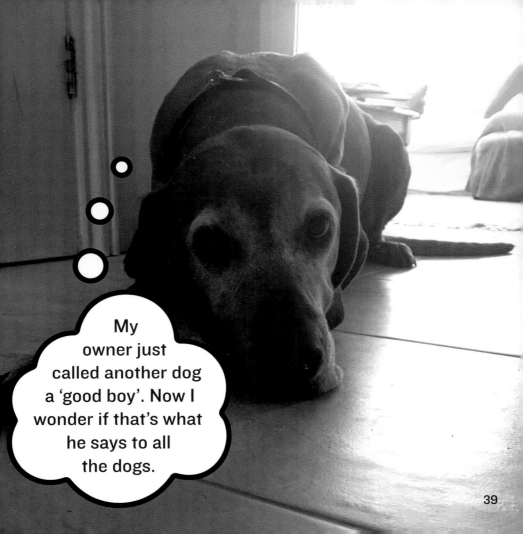

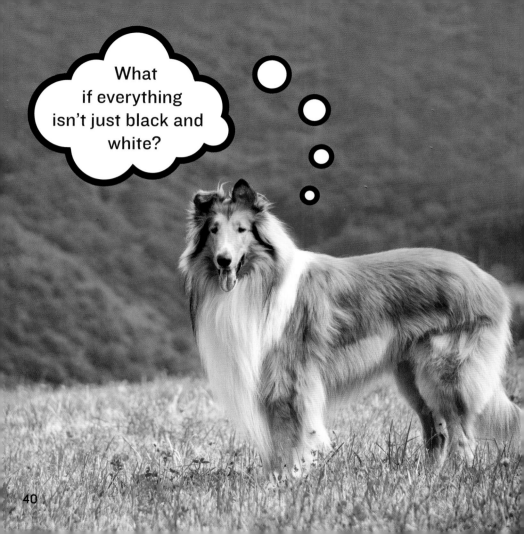

40

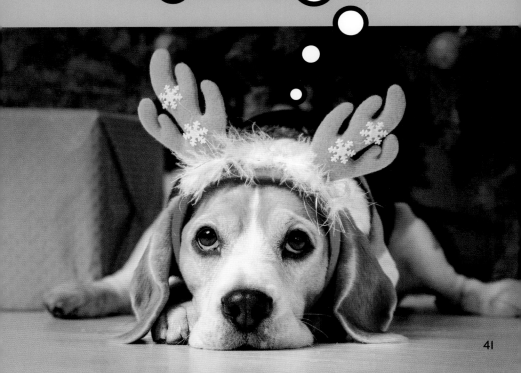

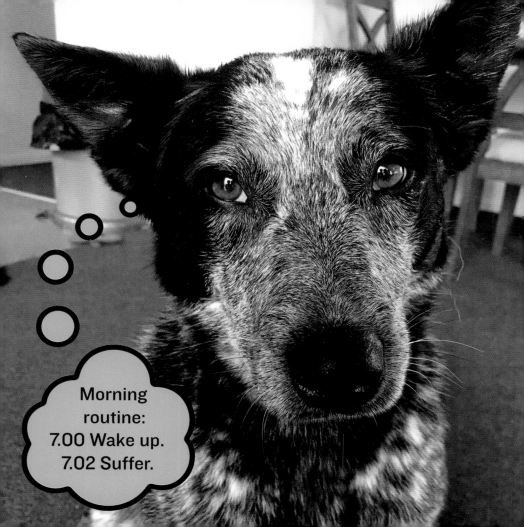

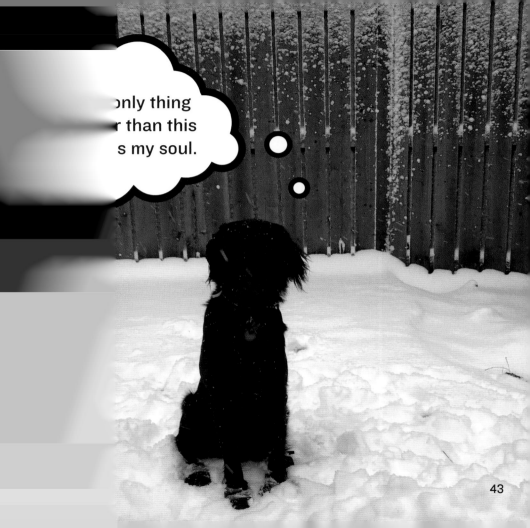

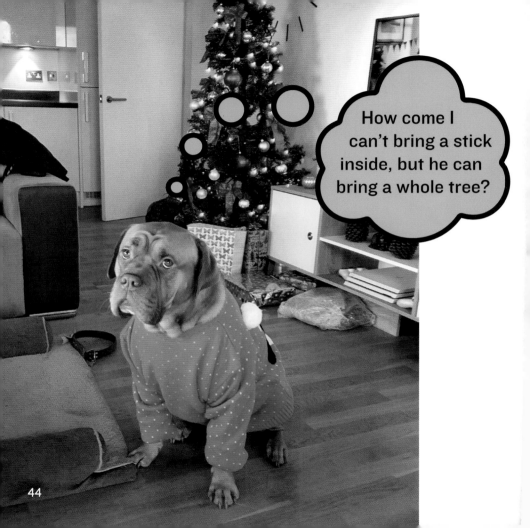

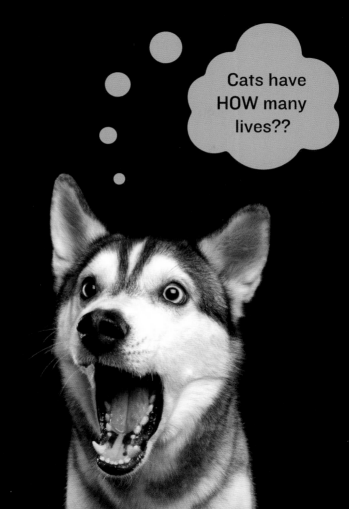

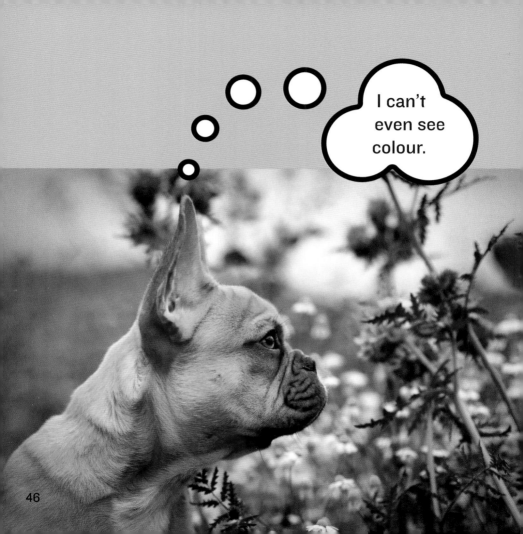

46

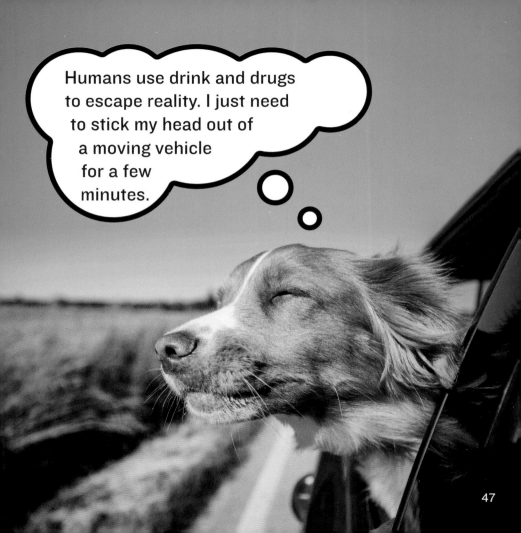
47

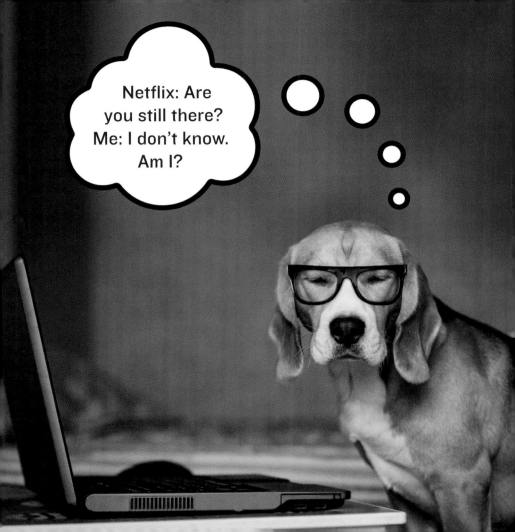

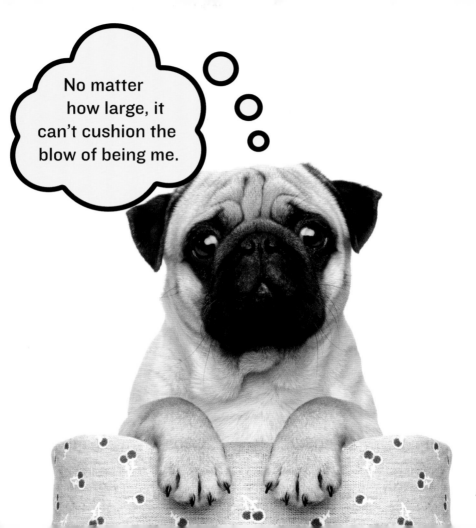

49

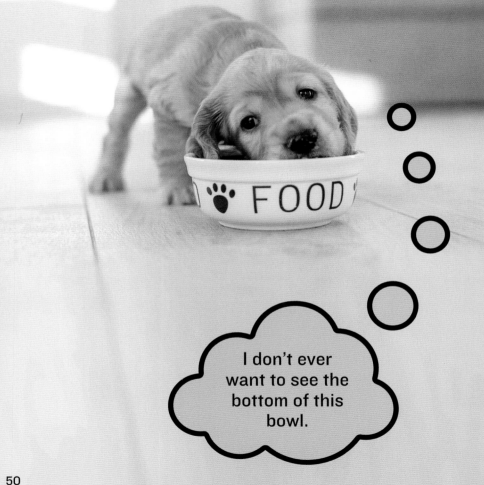

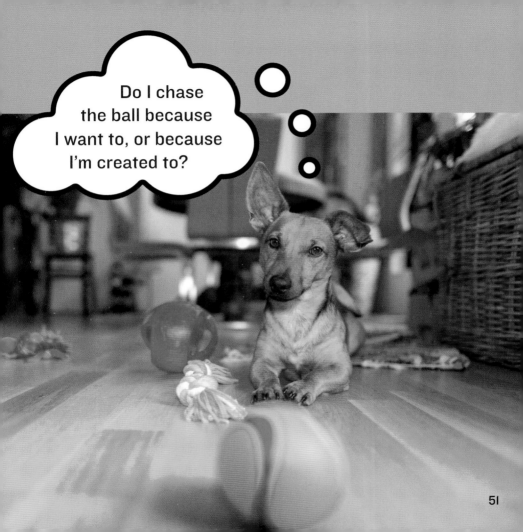

51

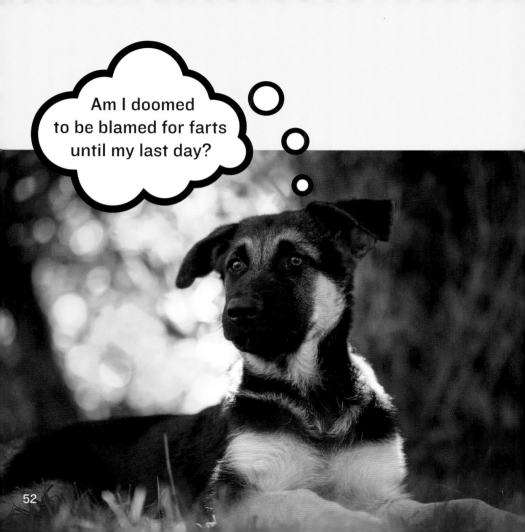

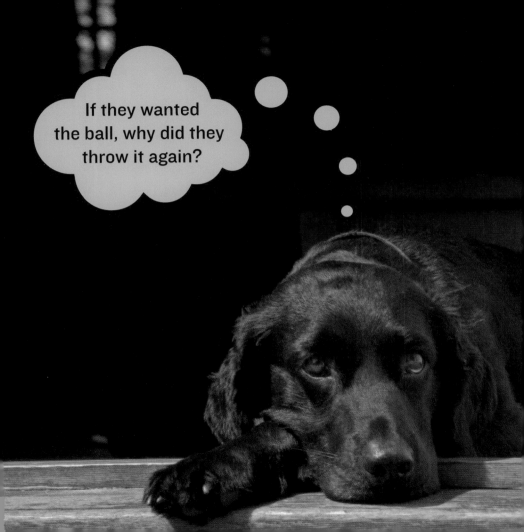

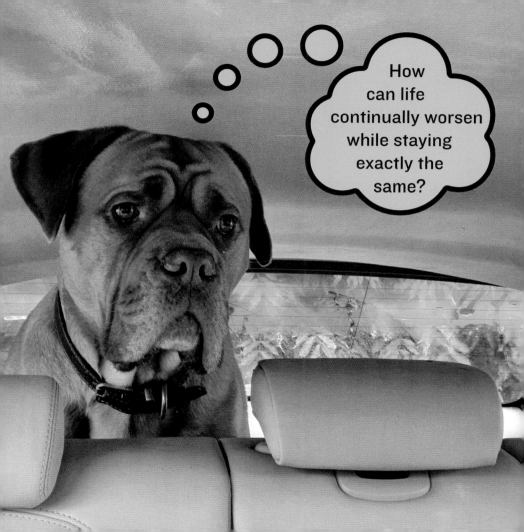

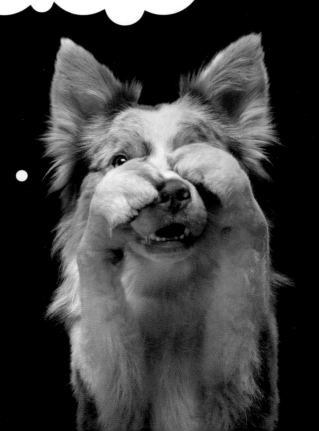

55

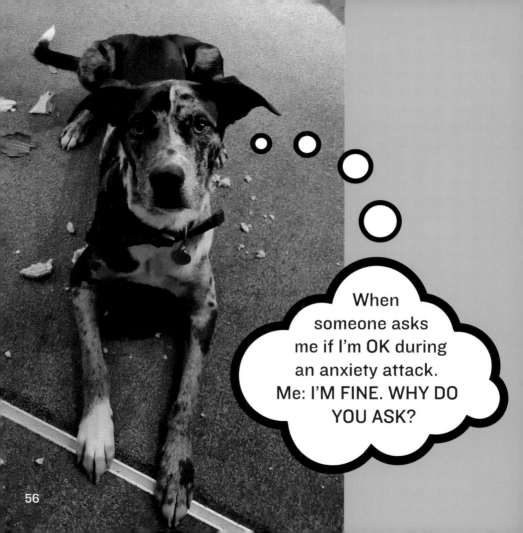

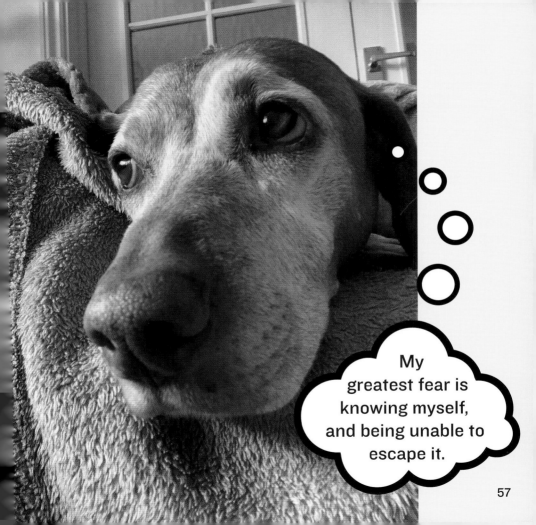

57

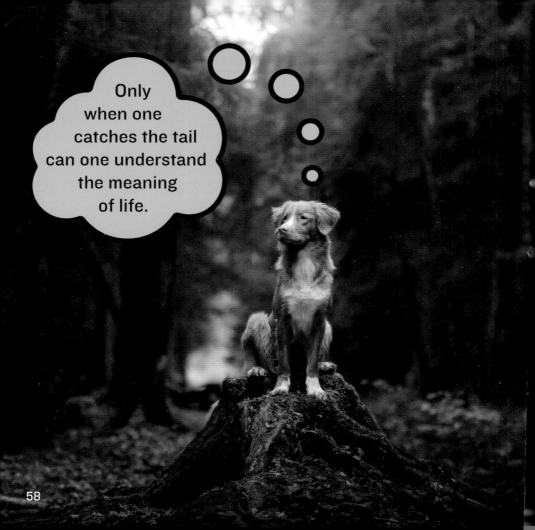

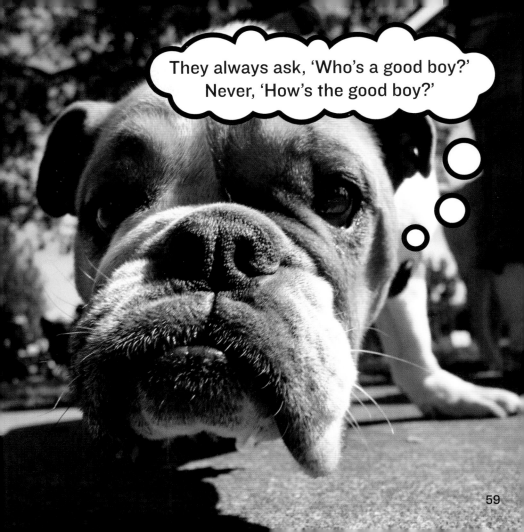

59

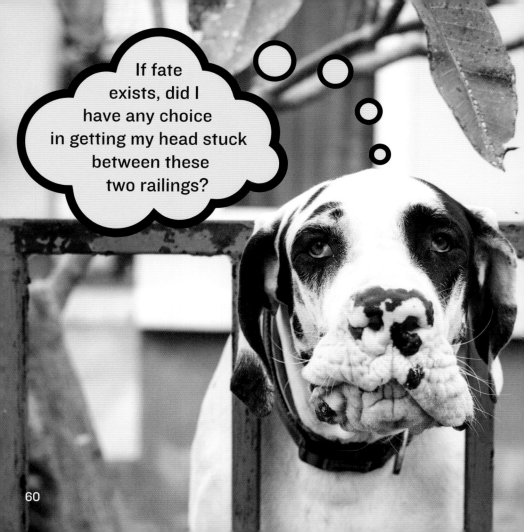

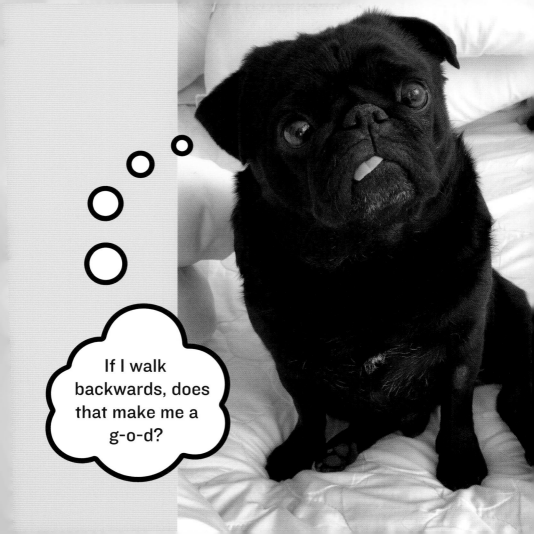

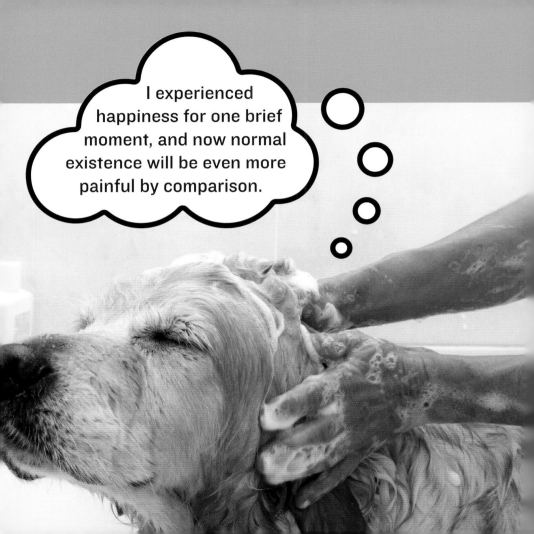

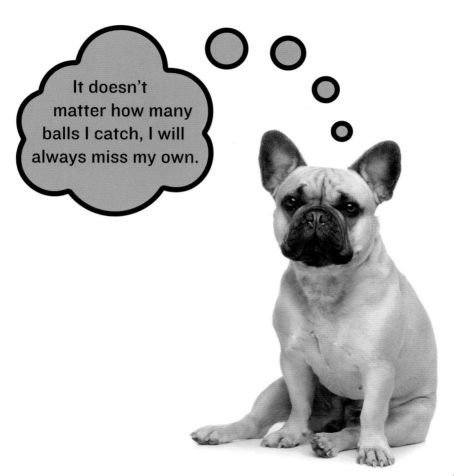

63

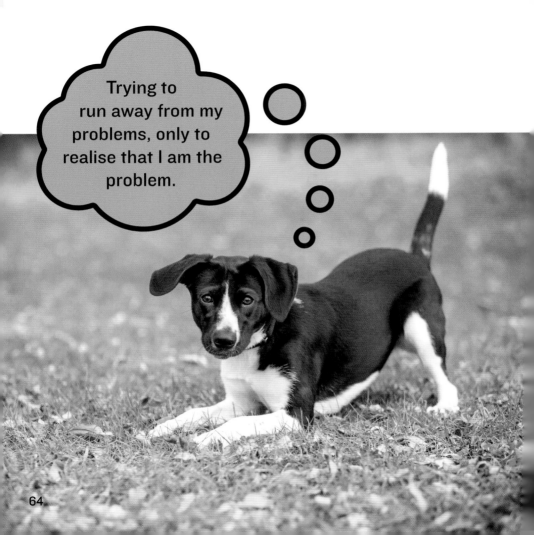

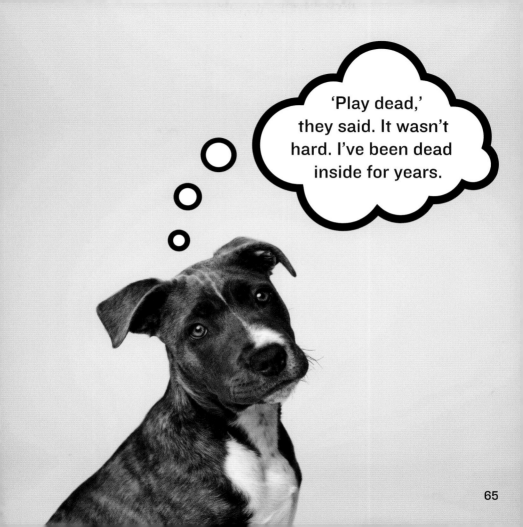

65

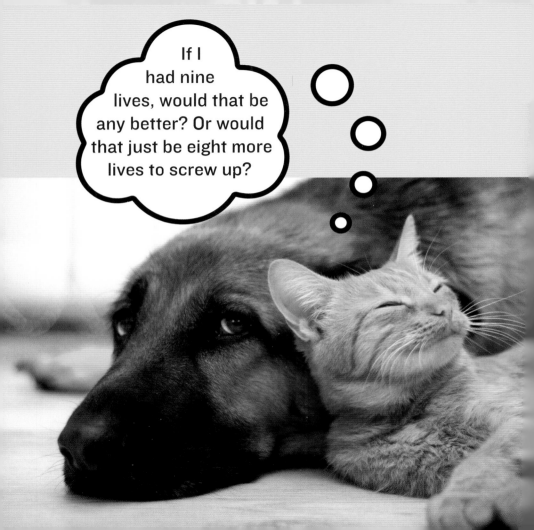

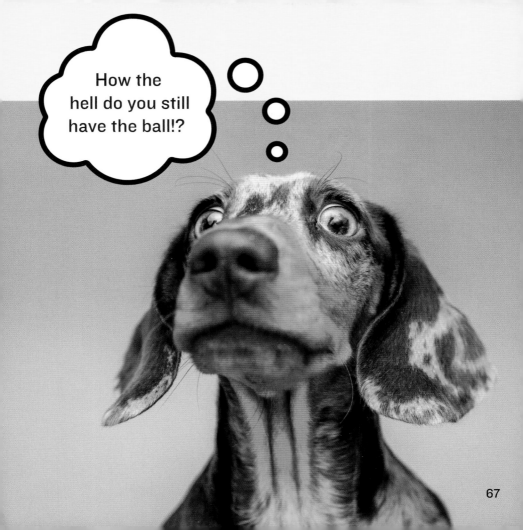

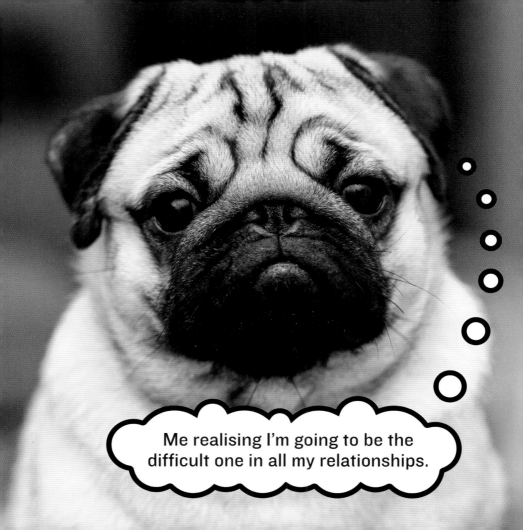

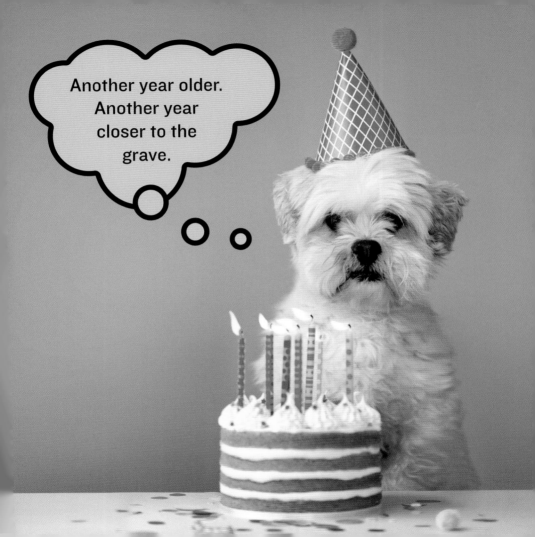

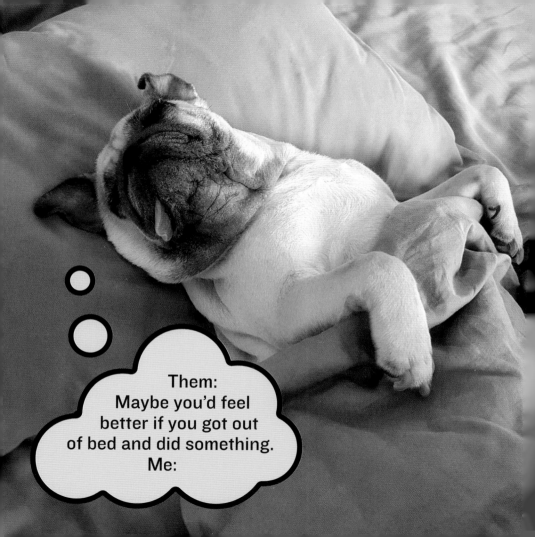

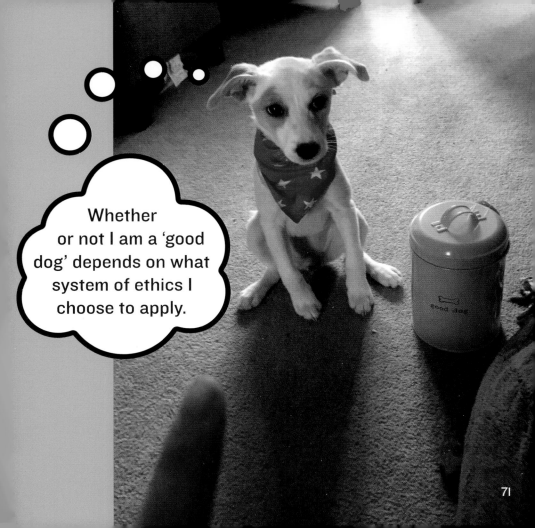

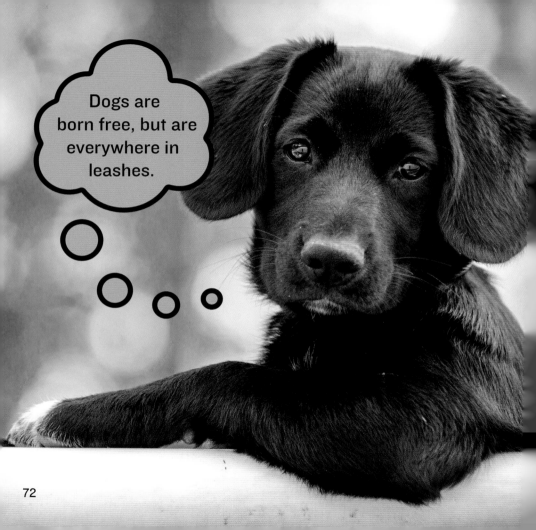

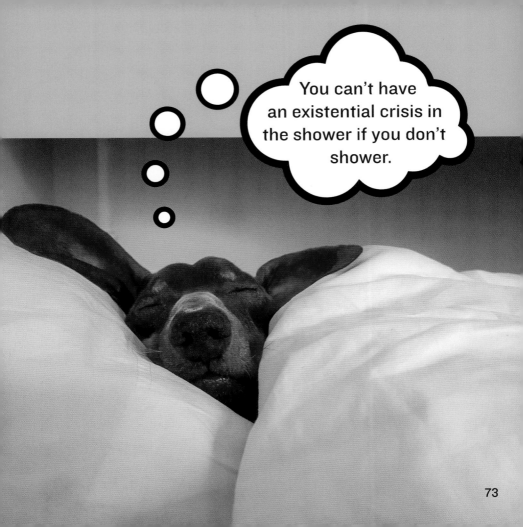

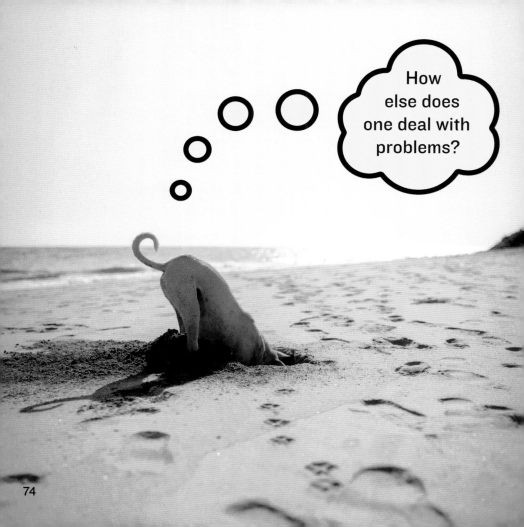

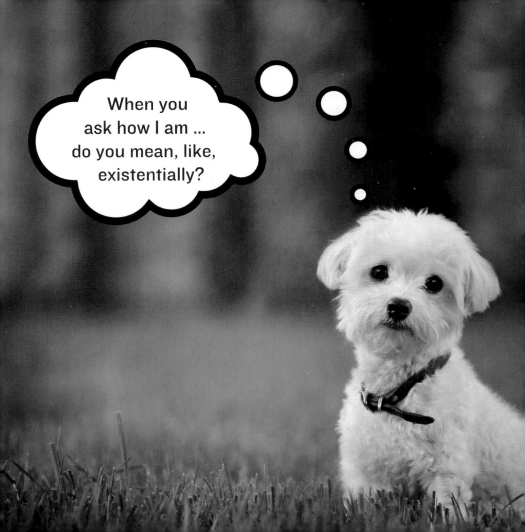

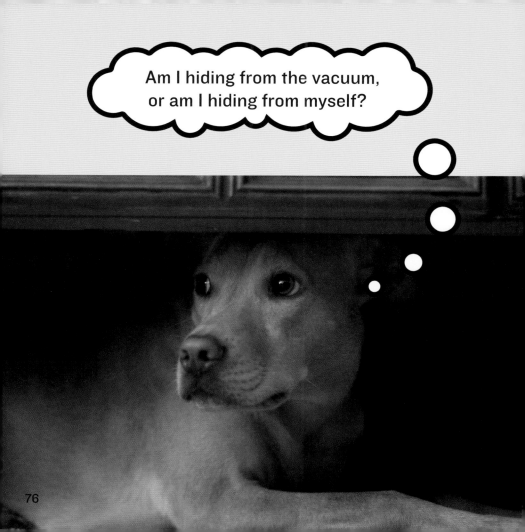

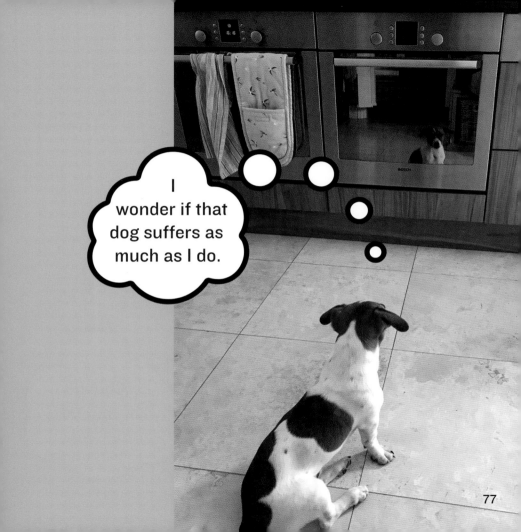

77

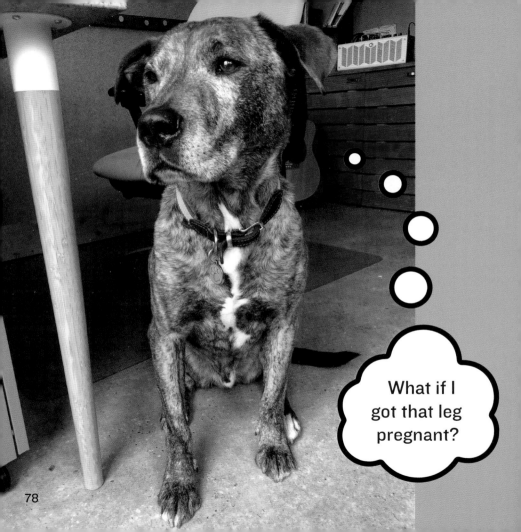

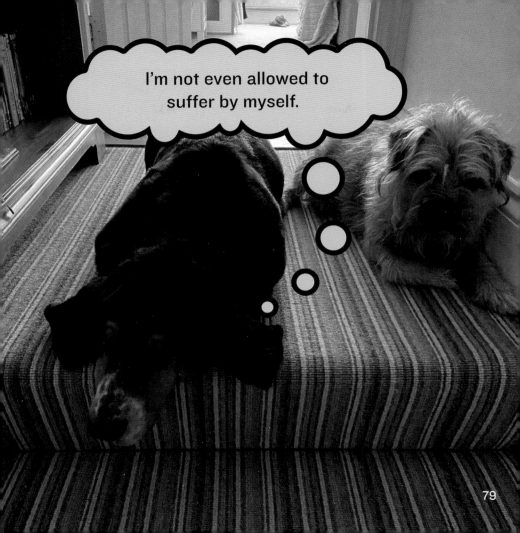

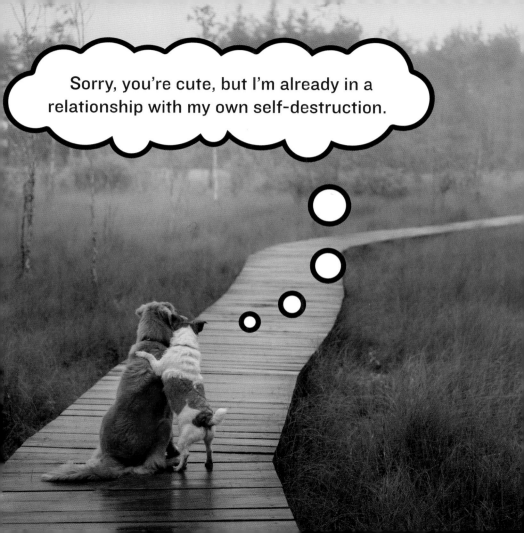

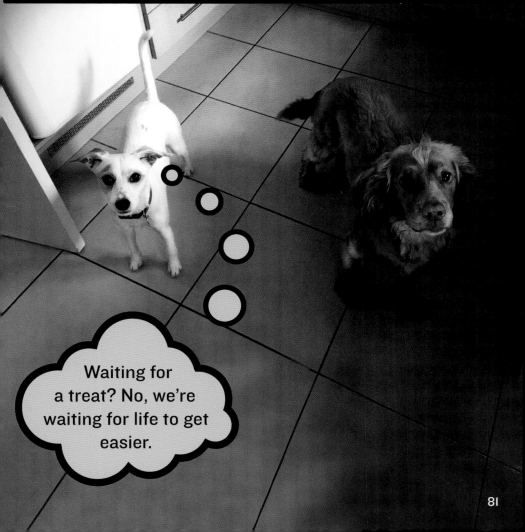

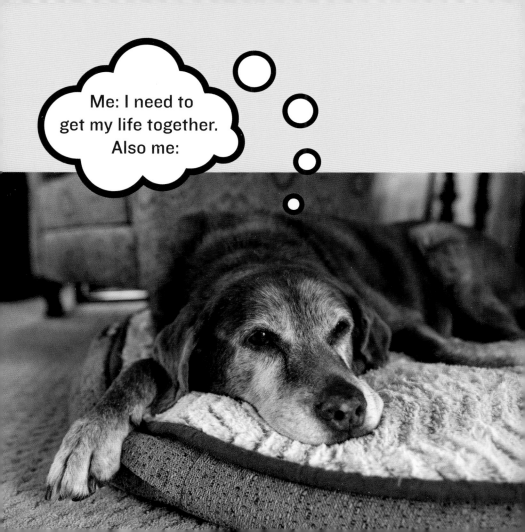

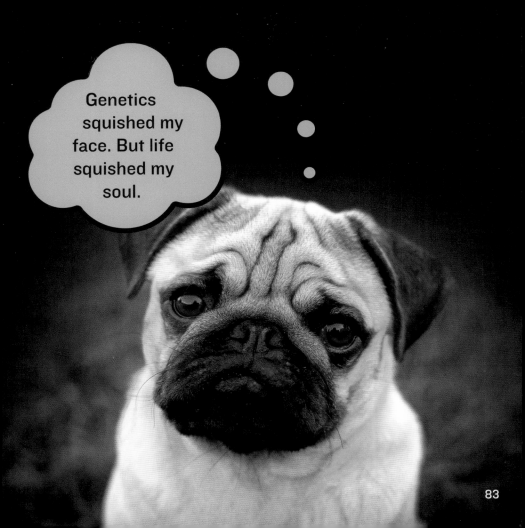

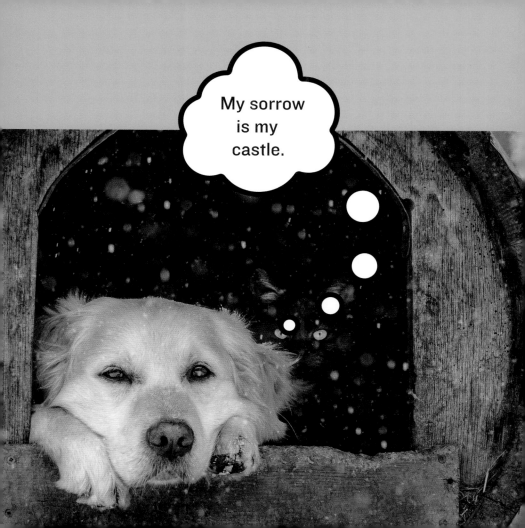

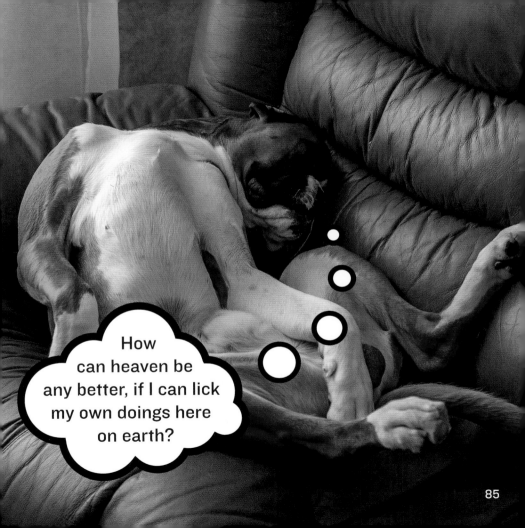

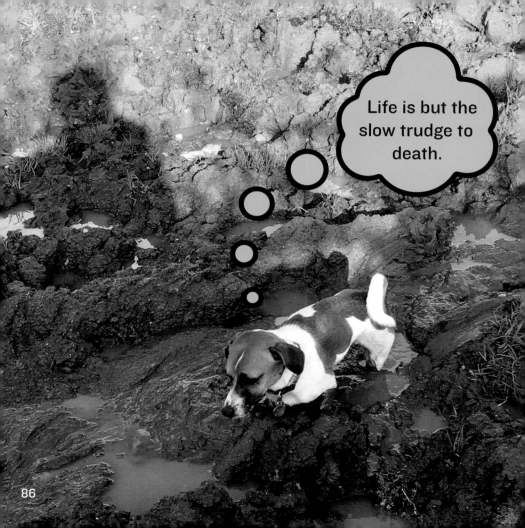

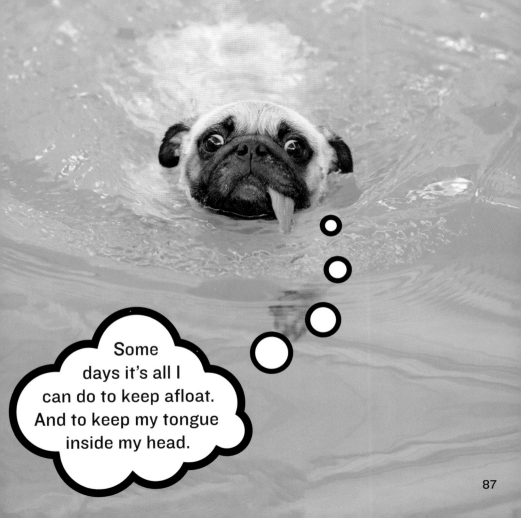

87

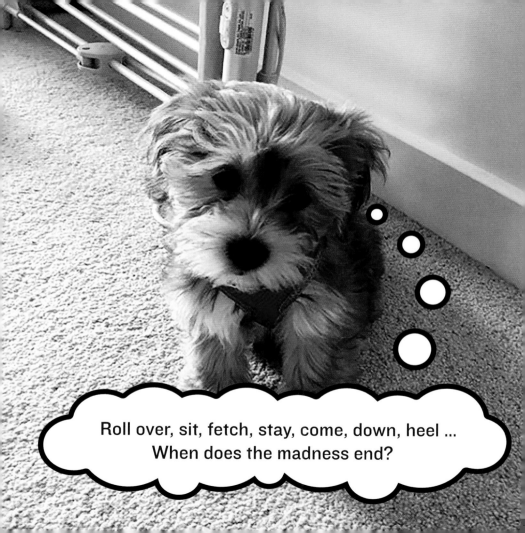

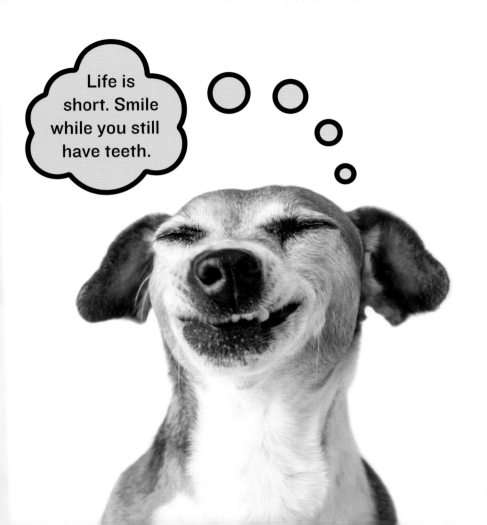

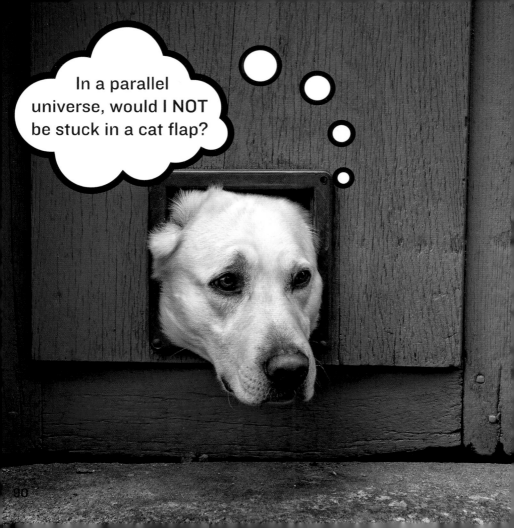

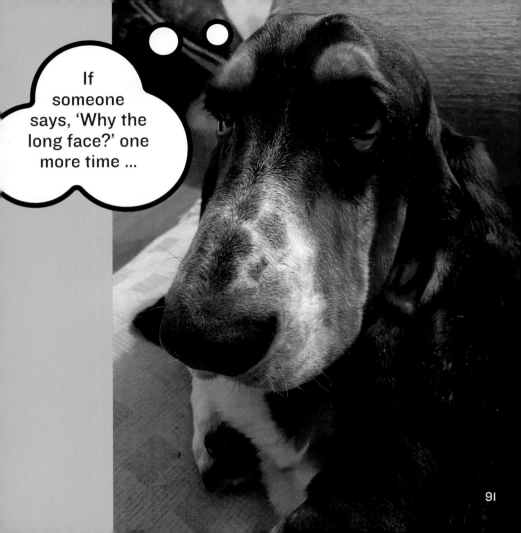

91

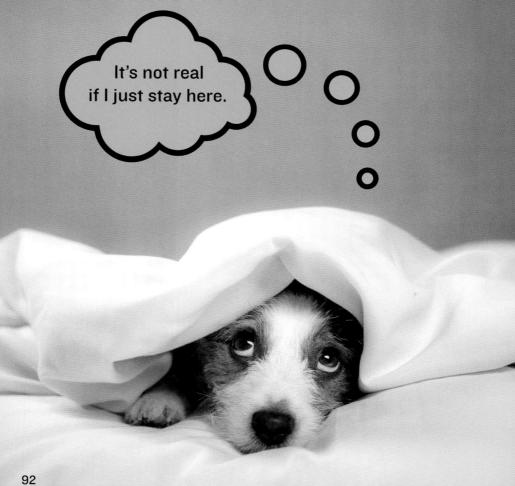

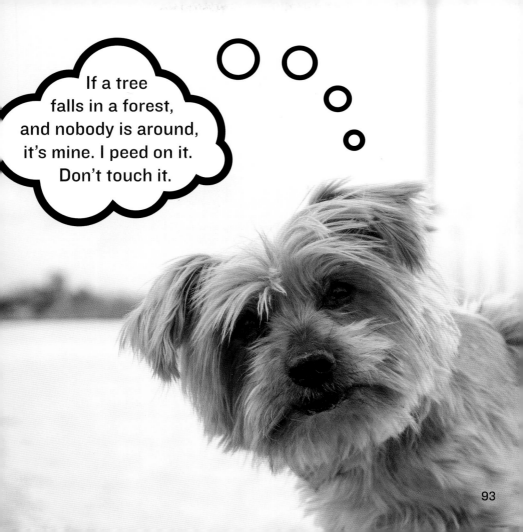

93

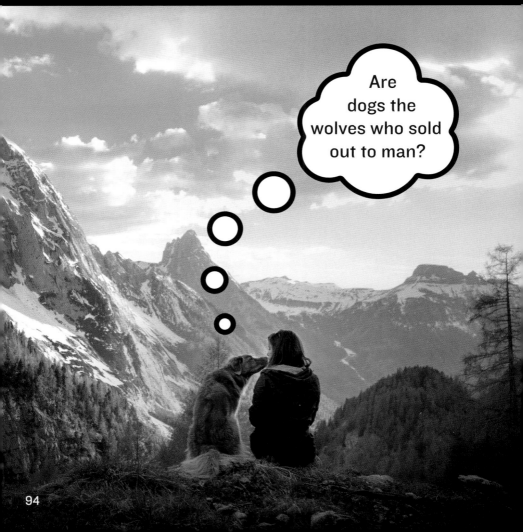

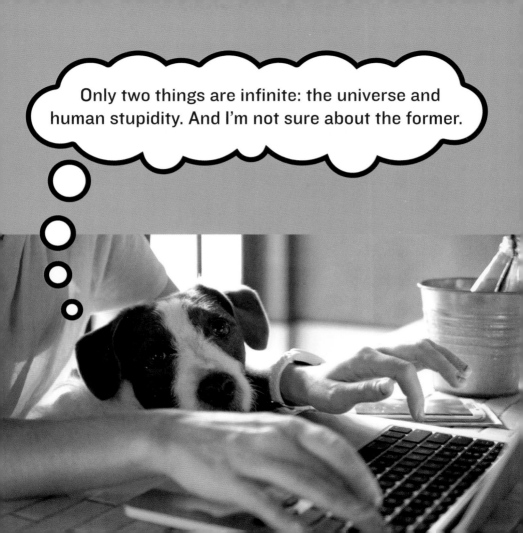

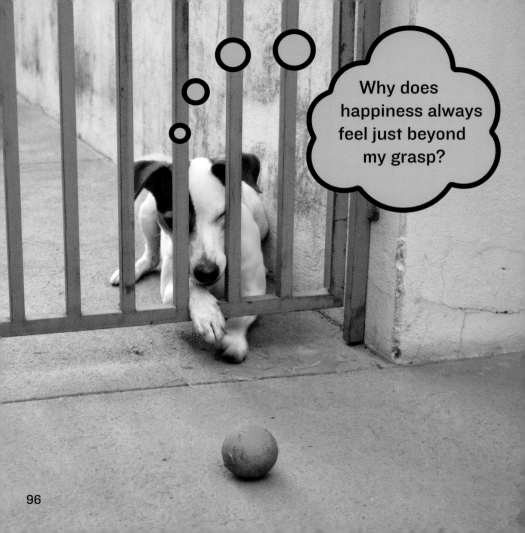

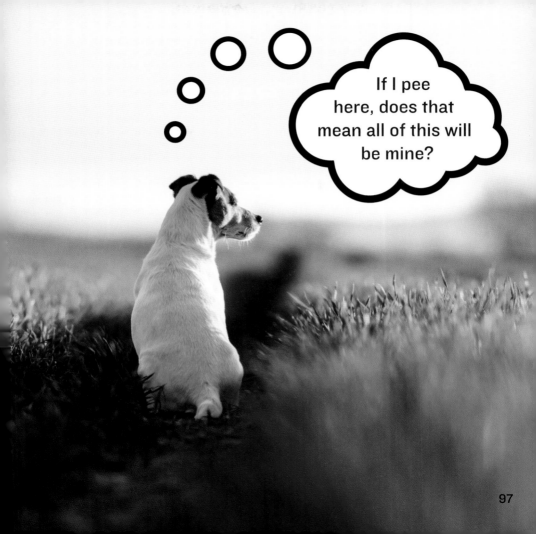

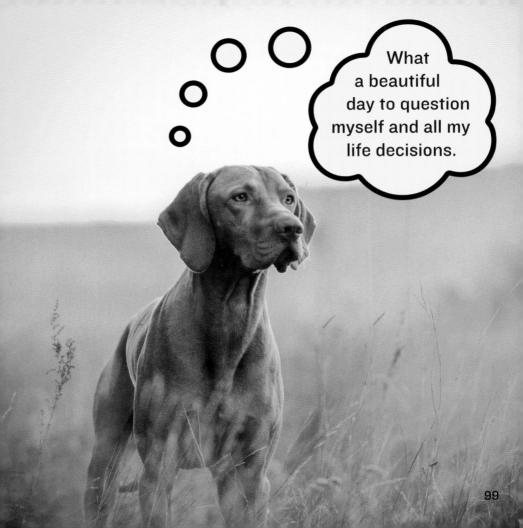

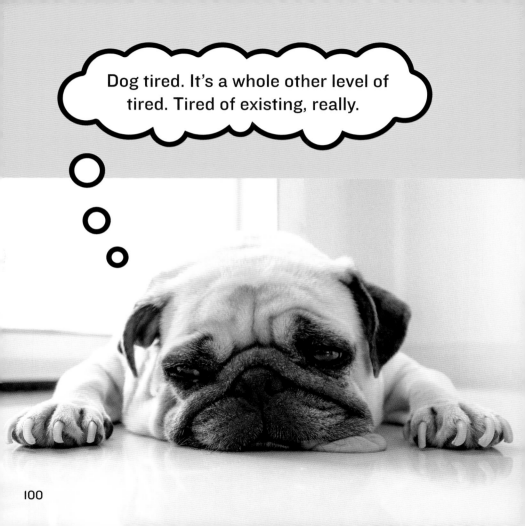

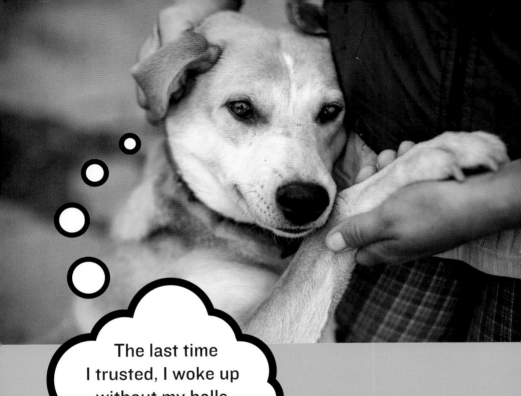

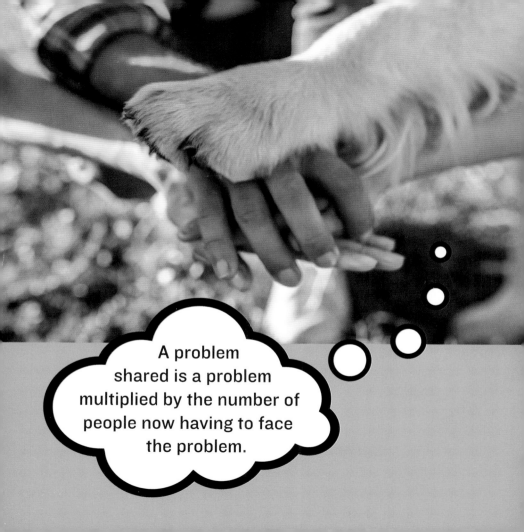

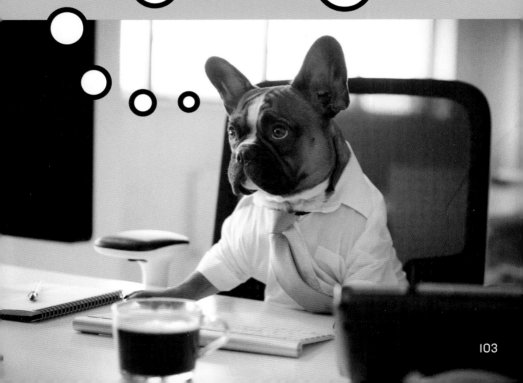

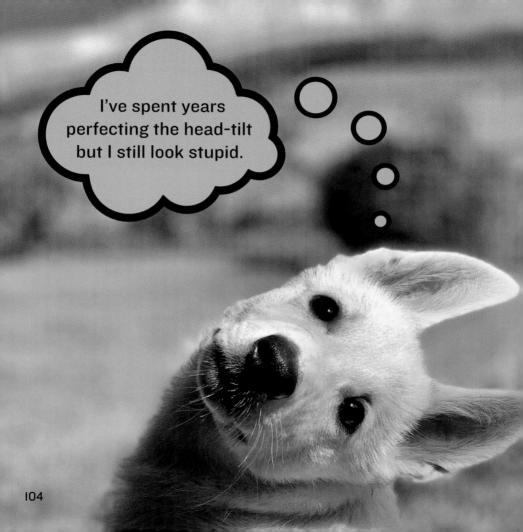

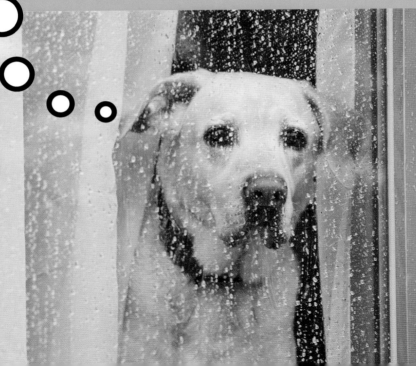

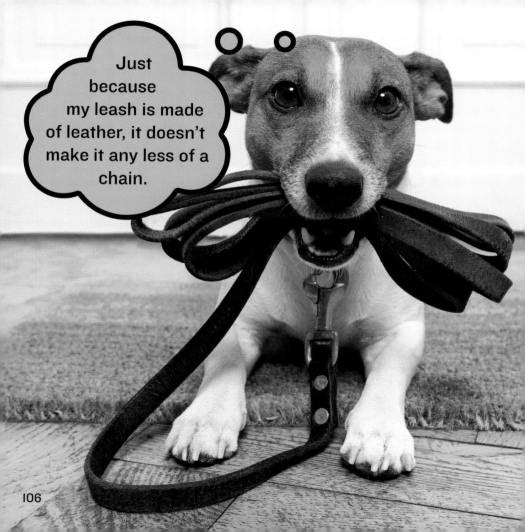

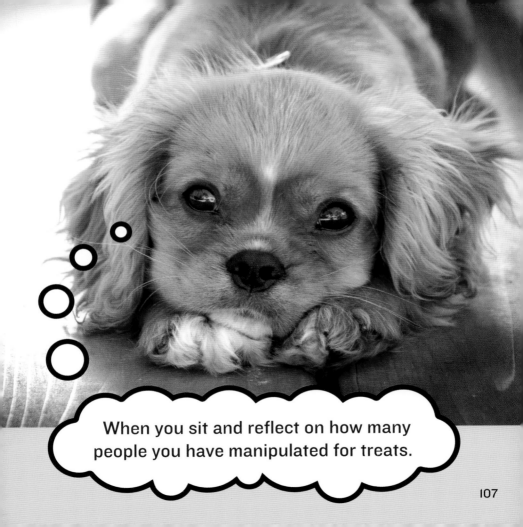

When you sit and reflect on how many people you have manipulated for treats.

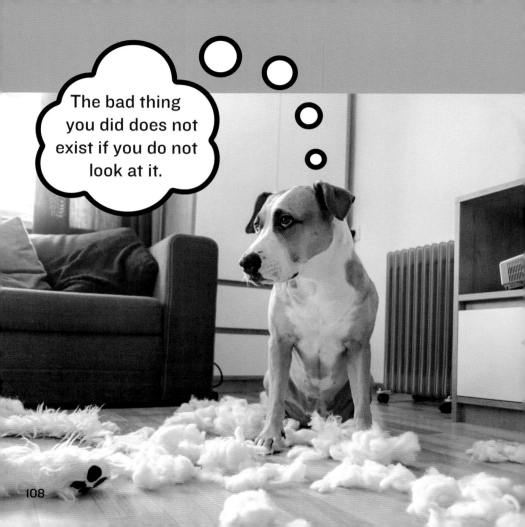

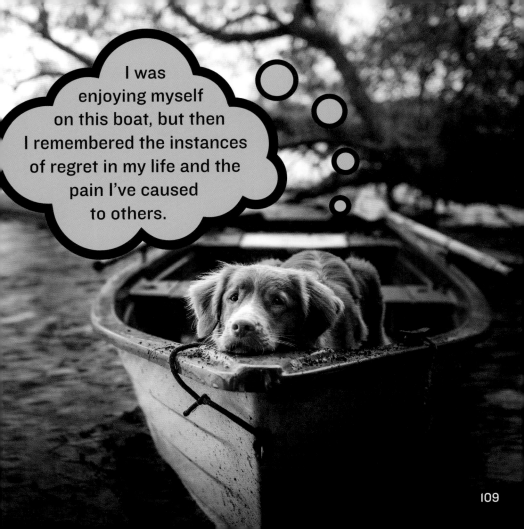

109

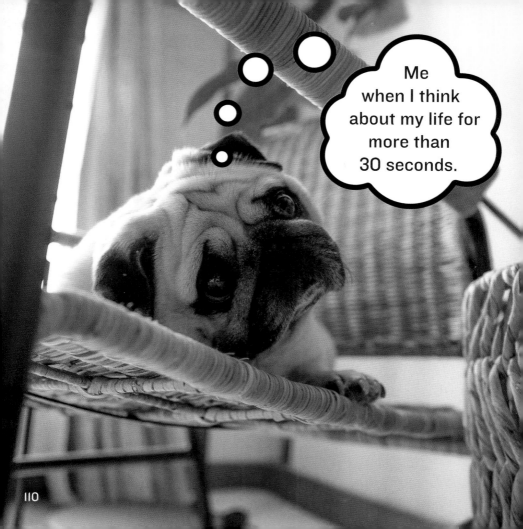

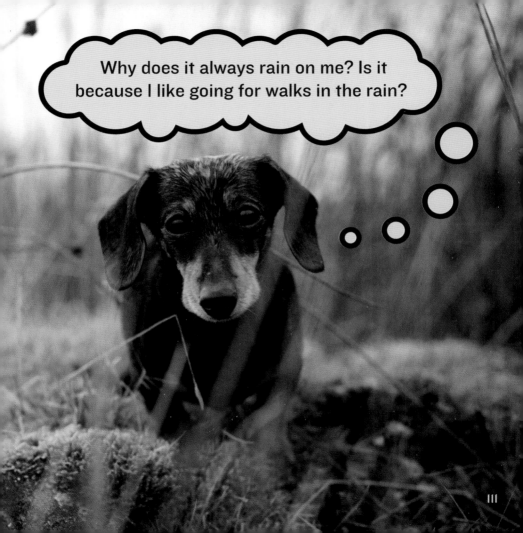

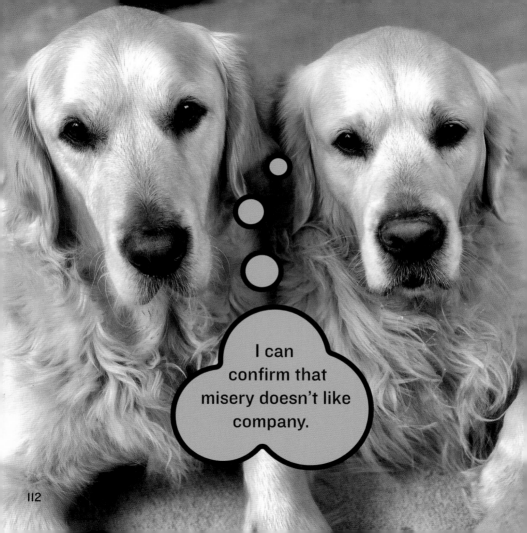

112

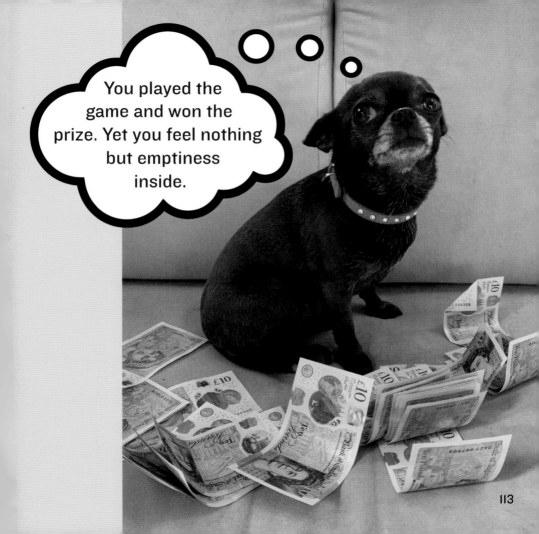

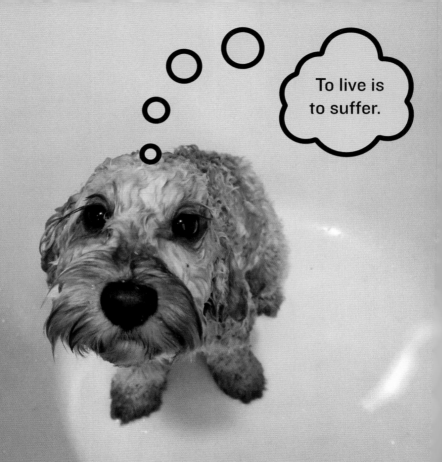

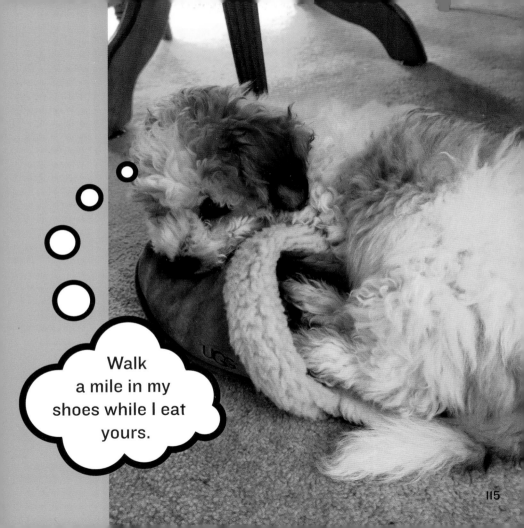

Walk a mile in my shoes while I eat yours.

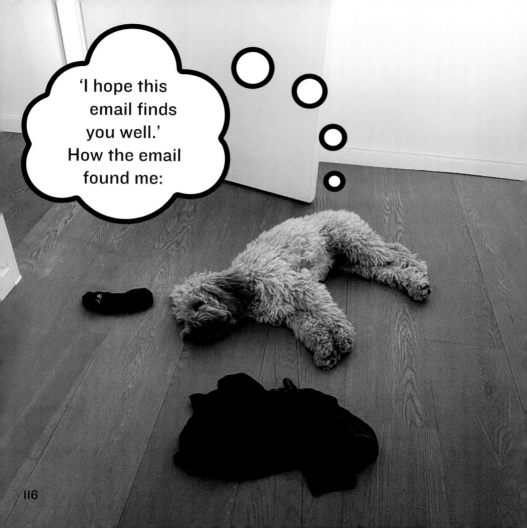

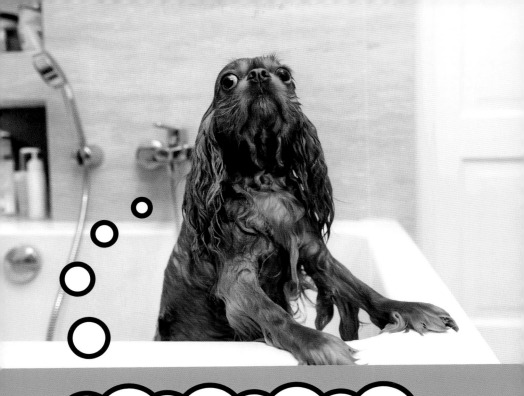

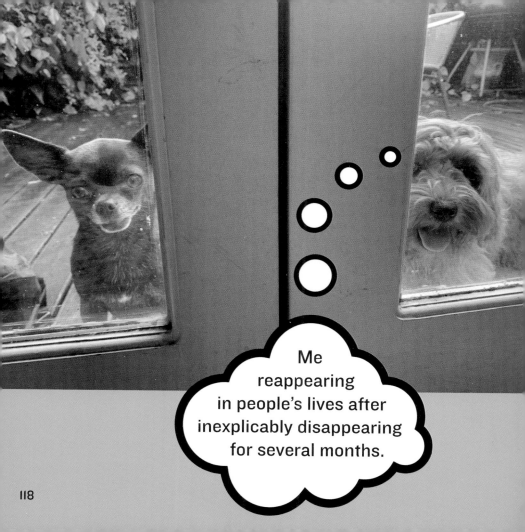

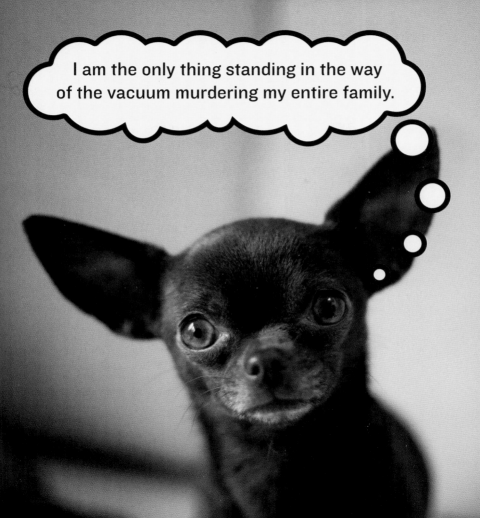

119

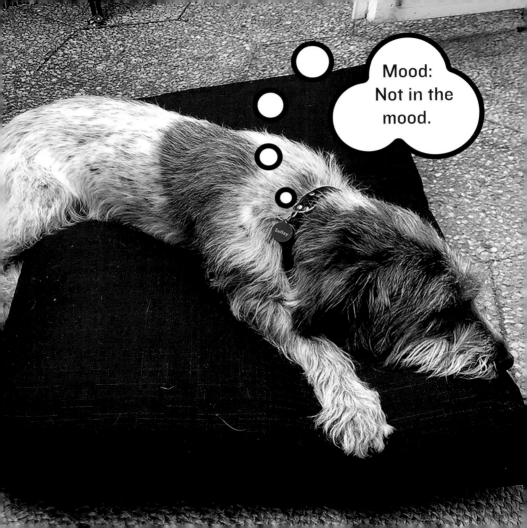

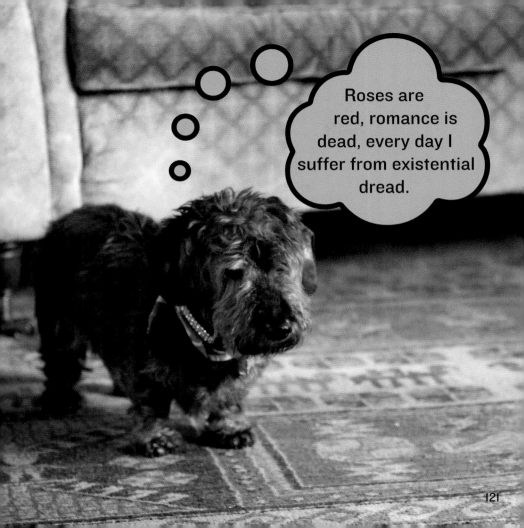

121

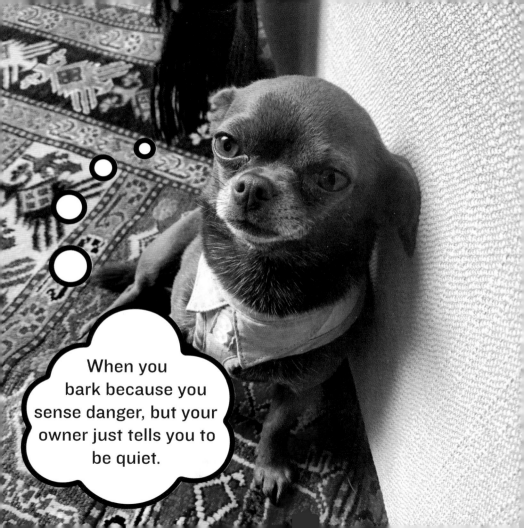

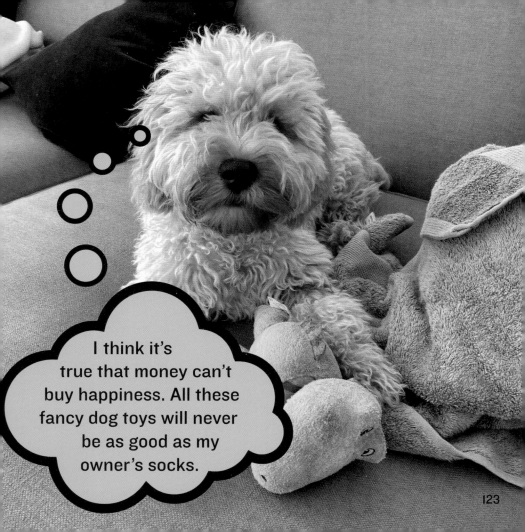
123

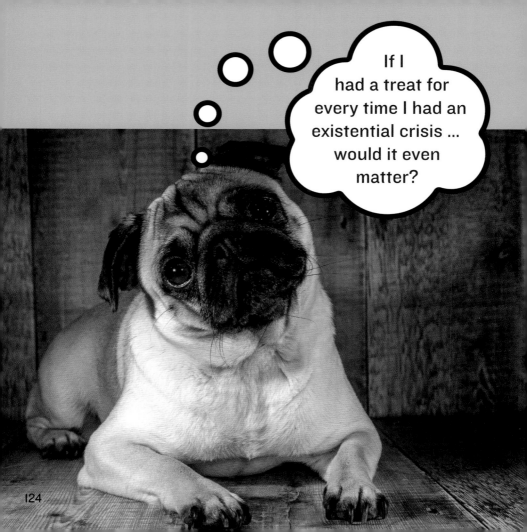

PICTURE CREDITS

While every effort has been made to trace the owners of copyright material reproduced herein and secure permissions, the publishers would like to apologise for any omissions and will be pleased to incorporate missing acknowledgements in any future edition of this book.

All photographs © Shutterstock.com, with the exception of the following: pl © Juliette Barnes and Kayley Higgins; p2 © Rikki Gorman; p3 © Jacob Greenall; p4 © Beatrix McIntyre; p5 © Saanya Sharma and Sharon Chinnappa; p7 © Chris Deacon; pl0 © Nicky Evans; pll © Rikki Gorman; pl2 © Sara Cywinski; pl3 © Lucy Oates; p20 © Lucy Vine; p23 © Vybarr Cregan-Reid; p24 © Maia Srebernik; p25 © Jacob Greenall; p26 © Jane Worrell; p30 © Nathan Goh; p3l © Emily Martin; p32 © Lauren Bensted; p33 © Juliette Barnes and Kayley Higgins; p35 © Sarah Garnham; p36 © Sarah Mortimore; p37 © Lucy Vine; p39 © Lucy Oates; p42 © Julia Eddington; p43 © Emily Martin; p44 © Rikki Gorman; p45 © Maia Srebernik; p53 © Vybarr Cregan-Reid; p54 © Rikki Gorman; p56 © Jacob Greenall; p57 © Lucy Oates; p6l © Juliette Barnes and Kayley Higgins; p7l © Maia Srebernik; p77 © Holly Masters; p78 © Sarah Mortimore; p79 © Sarah Garnham; p86 © Holly Masters; p88 © Lucy Vine; p9l © Sarah Garnham; p98 © Rikki Gorman; pll0 © @thepuggysmalls (Instagram); plll © @ladybelleofberkeley (Instagram); pll2 © @goldenriley_ (Instagram); pll3 © @pesalab (Instagram); pll4 © @tailsofthecity.nl (instagram); pll5 © @katiestaffy (Instagram); pll6 © @catstarr22 (Instagram); pll8 © @mgrowcoot (Instagram); pll9 © @mgrowcoot (Instagram); pl20 © Noor Houtakkers; pl2l © @mgrowcoot (Instagram); pl22 © @pesalab (Instagram); pl23 © @catstarr22 (Instagram); pl25 © Jonty Warner

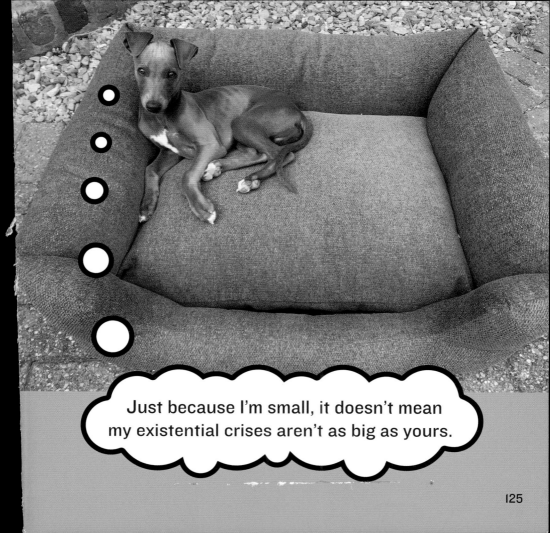